D0552960

THE DOLLS' HOSPITAL DIARIES

The History Press Ireland

To Kathleen Rose Brown (1916–2012), who loved her teddy bears

First published 2012

The History Press Ireland
50 City Quay
Dublin 2
Ireland
www.thehistorypress.ie

© C.M. Scaife, 2012
Photographs © Mella Travers & Bríd ní Luasaigh

The right of C.M. Scaife to be identified as the Author
of this work has been asserted in accordance with the
Copyrights, Designs and Patents Act 1988.

British Library Cataloguing in Publication Data.
A catalogue record for this book is available from the British Library.

ISBN 978 1 84588 763 6

Typesetting and origination by The History Press

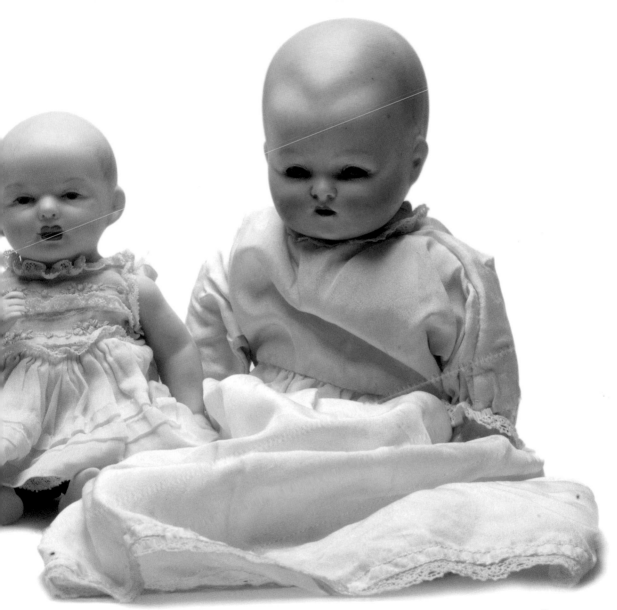

Dubliners remember the Dolls' Hospital on Mary Street with great fondness, and recall its owners as uniquely kind and gentle people. The Mary Street business closed in 1977; Freda Noyek died in 1990 and Tommy in 1996.

For seven long years, the dolls and teddy bears of Dublin had nowhere to go for treatment in the event of accident, illness or just the ravages of old age. But in 1984, a new Dolls' Hospital opened at 62 South Great George's Street, run by Melissa Nolan and her husband Chris.

Melissa Nolan had trained as a dollmaker and originally planned to create handmade dolls for the Irish market, but it was difficult to cover costs in such a specialised business without charging prohibitively high prices. In the meantime, she was receiving an increasing number of enquiries about repairs and restoration, until that side of the business began to take up most of her attention. As time went by, Melissa and her team developed more and more expertise, performing repairs on a huge variety of different toys of varying ages. 'We started with the simple repairs, replacing an arm and a leg', she recalled in an interview. 'It was the eyes that provided the challenge but I found a source for them in Germany and I was the only person in the country who could do them right.' Demand was always high and patients travelled to South Great George's Street from all over the world.

> 'We started with the simple repairs, replacing an arm and a leg'... 'It was the eyes that provided the challenge'

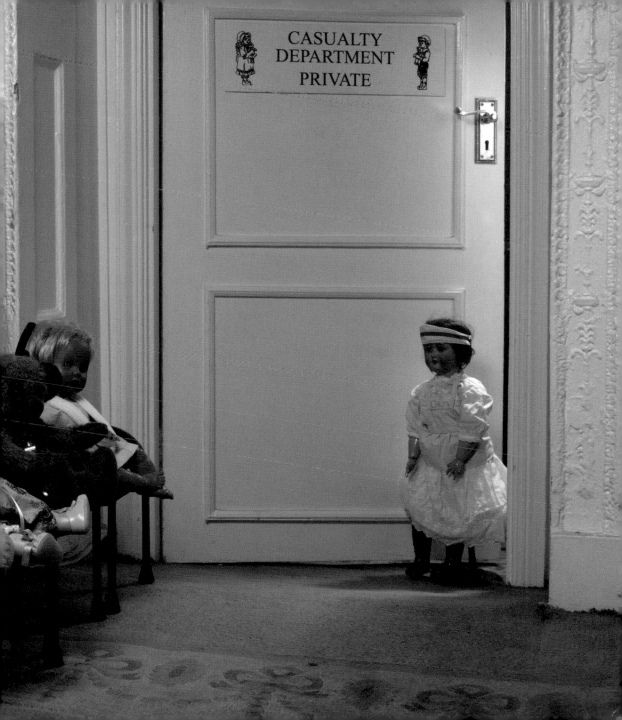

Shortly after the new Dolls' Hospital opened, the Nolans were contacted by the former manager of the Crolly Doll Factory in County Donegal, which had closed in 1979. He offered them a large number of leftover doll parts and, since many of the dolls coming in to the Hospital for repair were made by the Crolly Doll company, the Nolans were delighted to take this opportunity. 'Arms, legs, eyes, shoes, they were all being stored in a broken-down ambulance in a field in Donegal. I bought the lot', Melissa recalled years later.

In 2007 the Dolls' Hospital expanded into an online business, www.dollstore.ie. They started selling dolls' houses and everything that goes with them: furniture, pots and pans, cups and saucers, fireplaces, miniature musical instruments, flowers and trees for the garden, and a great deal more besides. If the dolls' house was feeling chilly, its residents could avail themselves of a tiny hot water bottle; if the weather was nice they might want to relax in the miniature conservatory…

But conditions in the outside world were not so benign, and the Dolls' Hospital was starting to experience some serious problems. Ironically, although it had thrived during some of the most difficult economic conditions of twentieth-century Ireland – through the recessions of the 1950s and the 1980s – the Celtic Tiger years exacted a heavy toll on the Hospital, as they did on many other small businesses with premises in the centre of Dublin. Year on year city-centre rents continued to rise, and by January 2012 the Nolans' overheads spiralled to the point where they had to announce the closure of the shop.

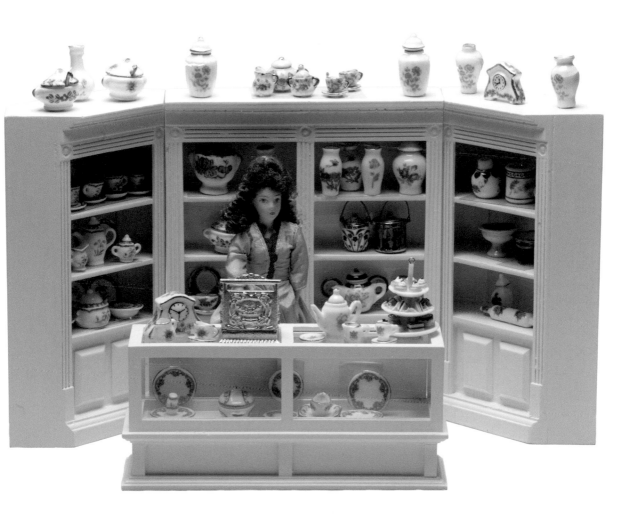

The Dolls' Hospital had survived the bad times, but it seemed that the good times might have finally destroyed it…

The public reaction was overwhelming. On the last day of trading, Saturday 4 February, hundreds of people visited to say goodbye to an institution which had shaped their childhood. Queues formed onto the street outside and more than a few tears were shed.

But the story wasn't over yet. The extensive press coverage, documenting the flood of visitors from all over the country and recording their shock and sadness, had an unprecedented result, as the Nolans began to receive offers of alternative locations. A week later, they were able to announce that the Hospital had been saved at the eleventh hour. They had been offered a wonderful (and affordable) space in the old Georgian ballroom at the Powerscourt Townhouse Centre on South William Street.

Moving everything to the new premises was no easy business, but all the patients arrived unscathed, as did the distinctive 1940s mahogany cabinets and showcases which had been such a feature of the South Great George's Street shop. In the new space, Melissa was able to achieve a long-held ambition and set up a Museum of Childhood displaying the large collection of vintage dolls and teddy bears which she had accumulated over many years.

The Dolls' Hospital reopened for business on 12 March 2012 and marked the occasion with a special children's day, featuring face-painting, balloons and life-sized teddy bears greeting all guests at the door. The new premises were thronged with visitors, including

customers old and new, and the shop was officially opened by Children's Minister Frances Fitzgerald, who spoke warmly about the importance of this 'wonderful history of toys and childhood'.

But what exactly lies behind our love affair with dolls and teddy bears? How long has it been going on? And what can we learn about it by peeping through the brightly-lit windows of the Dolls' Hospital?

'Gather round, children, and let me tell you a story…'

A Dublin Story

Gertie Kiersey, our oldest customer, was born on 7 July 1914. Gertie has a remarkable tale to tell about her experiences on Easter Monday 1916, when she was just a year and nine months old. Early that morning, while Gertie was sleeping peacefully at home in Harold's Cross, Irish Volunteers and Citizen Army members were gathering across Dublin, preparing to take over a number of key locations: the General Post Office, the Four Courts, Jacob's Biscuit Factory, Boland's Bakery and flour mills, the South Dublin Union, St Stephen's Green and the College of Surgeons. Around noon, the Rising claimed its first casualty, James O'Brien, an unarmed police constable guarding Dublin Castle. By the time it was all over on the following Sunday, hundreds of lives had been lost, and many of the victims were civilians.

On that Monday morning, Gertie was woken by the sound of gunshots, as British troops fired on rebels crossing the canal from the city centre. Above her cot in a glass case was her mother's beautiful and cherished French doll. Suddenly, the glass case

Suddenly, the glass case shattered

shattered into pieces as a stray bullet whizzed through the window and embedded itself in the doll. The doll went flying through the air and landed in the cot beside Gertie, who was frightened but completely unharmed.

Gertie has the doll to this day, and you can still see the mark of the bullet. She and the doll have witnessed many changes in Dublin throughout the last century, and there aren't many people left now who can remember the turbulent times the city experienced in the early decades of the twentieth century. Gertie has been a customer of the Dolls' Hospital since she was 23 years old and is still a regular visitor.

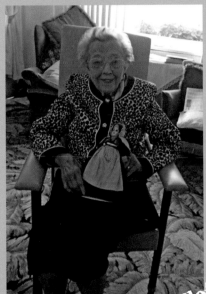
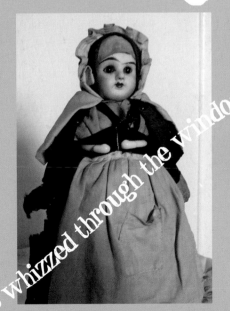

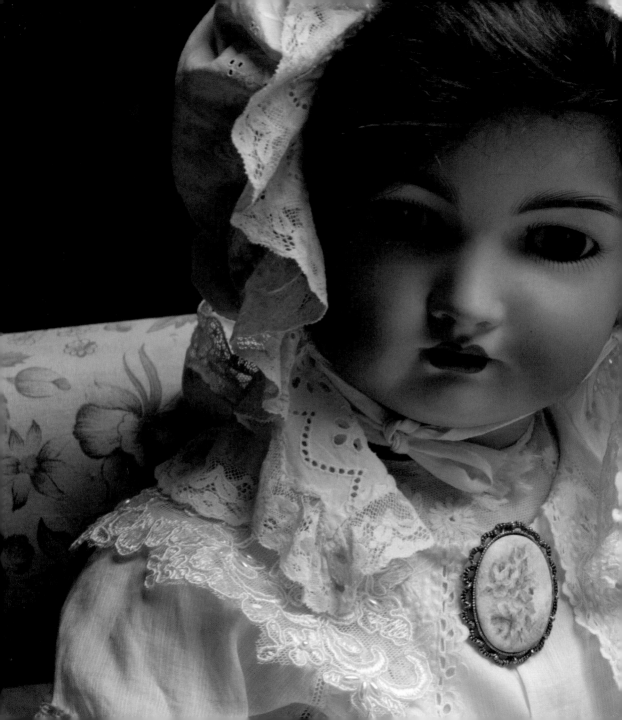

1

EARLY DOLLS

The likelihood is that children have always played with dolls in some shape or form. But where dolls from ancient civilisations have survived to the present day, it is often very difficult to judge whether they were actually used as children's toys or whether they were objects dedicated to religious or ritual purposes.

We are on safer ground when it comes to ancient Greece, where dolls were definitely used as playthings. These early dolls were made from burnt clay and were jointed in the same way as their modern counterparts, with their arms and legs hooked onto the body with string or cord. Antonia Fraser in her *History of Toys* points out that Plutarch, writing as early as the first century AD, describes his two-year-old daughter Timoxena asking her nurse to give milk not only to her but also 'to her babies and dolls, which she considered as her dependents, and under her protection'. In Roman times, children played with clay dolls and rag dolls, and the Latin word for a new-born child, *pupa*, found its way into later languages as the word for a doll: *poupée* in French and *Puppe* in German (related to the words *puppet* and *poppet* in English).

In the Middle Ages, the carved wooden doll came into its own, and for centuries this was by far the most popular toy. The first recorded dollmaker was working at Nuremberg in Germany as early as 1413.

From the fourteenth century onwards, dressmakers used dolls to demonstrate the latest fashions to the ladies of the European courts. When the dolls had finished their modelling stint, they were given to the customers' daughters to play with. A famous portrait of Lady Arabella Stuart at the age of 23 months, painted in 1577, shows her clutching in her left hand a doll dressed in full Elizabethan regalia. The doll's clothes are in a style popular a few years previously, so she must have been passed on to Arabella after she outlived her usefulness as a fashion model.

She came home from school one day and her only doll –

A Family Story

"It's quite common to hear stories from older people about how their doll or their bear mysteriously vanished one day. There was a very different attitude then to child psychology and child development and parents often had no idea how traumatic the experience might be. Toys would be taken away and given to younger children, or to children who couldn't afford them, or the parents would simply consider that their child was too old for a particular toy. One of our customers told us that she came home from school one day and her only doll – which she adored – was nowhere to be seen. She asked her mother and father where it had gone, and all they could say was that she was too big to play with dolls now.

She never forgot the doll and over the years she often asked her parents where it was. Had they given it away? Thrown it out? Stored it somewhere? But they always avoided her questions. After her parents died and before the family home was sold, she went up into the attic. The first thing she put her hand on was the doll. It had been up the attic, waiting for her, for fifty years. Obviously her mother and father had never quite been able to bring themselves to get rid of it – a feeling we can well understand."

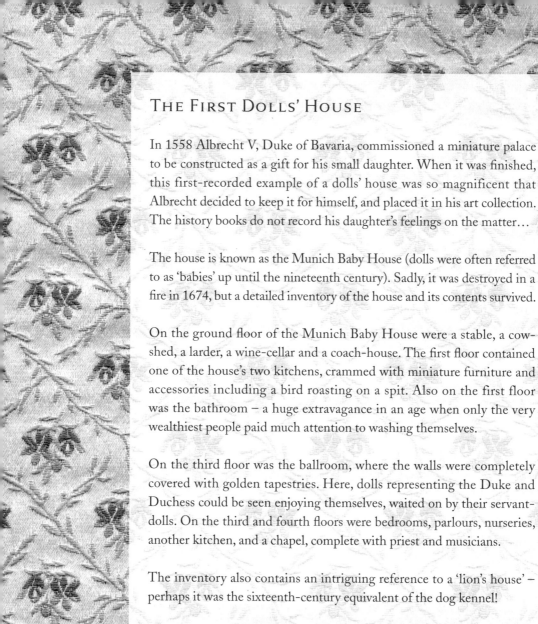

THE FIRST DOLLS' HOUSE

In 1558 Albrecht V, Duke of Bavaria, commissioned a miniature palace to be constructed as a gift for his small daughter. When it was finished, this first-recorded example of a dolls' house was so magnificent that Albrecht decided to keep it for himself, and placed it in his art collection. The history books do not record his daughter's feelings on the matter…

The house is known as the Munich Baby House (dolls were often referred to as 'babies' up until the nineteenth century). Sadly, it was destroyed in a fire in 1674, but a detailed inventory of the house and its contents survived.

On the ground floor of the Munich Baby House were a stable, a cow-shed, a larder, a wine-cellar and a coach-house. The first floor contained one of the house's two kitchens, crammed with miniature furniture and accessories including a bird roasting on a spit. Also on the first floor was the bathroom – a huge extravagance in an age when only the very wealthiest people paid much attention to washing themselves.

On the third floor was the ballroom, where the walls were completely covered with golden tapestries. Here, dolls representing the Duke and Duchess could be seen enjoying themselves, waited on by their servant-dolls. On the third and fourth floors were bedrooms, parlours, nurseries, another kitchen, and a chapel, complete with priest and musicians.

The inventory also contains an intriguing reference to a 'lion's house' – perhaps it was the sixteenth-century equivalent of the dog kennel!

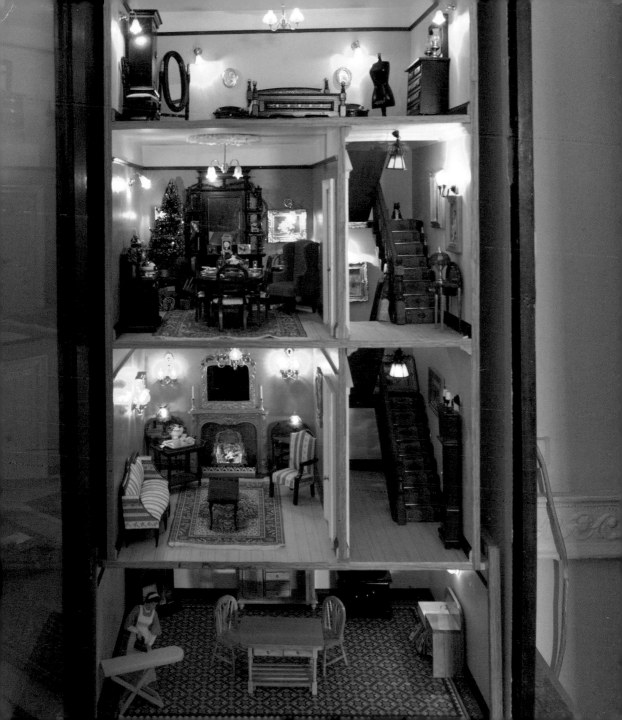

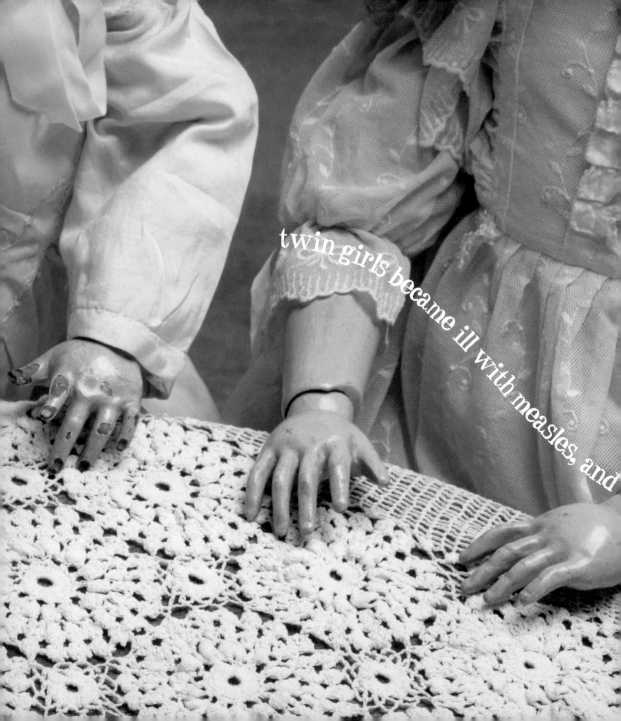

twin girls became ill with measles, and

A Twin Story

A number of sets of twin dolls have come in to the Dolls' Hospital over the years. Once we were asked to repair a doll under very sad circumstances: twin girls became ill with measles, and one of them drew spots all over the face of her twin's doll, thinking that the spots would disappear when the doll 'got better'. Tragically, the twin died, and the surviving child became very attached to her sister's doll. As time went by, the ink from the spots started to spread inside the plastic until the whole doll was in danger of being ruined, so the family brought it in to us to see if we could save it. Luckily, we were able to clean and repair the doll, which meant so much to the little girl.

ne of them drew spots all over the face of her twin's doll

On another occasion, an elderly lady came in with a pair of twin dolls, identical in every respect except that one had brown eyes and one had blue eyes. She explained that they had belonged to her and to her twin sister, who had recently died. She was worried that the dolls might become separated, so she asked if we could give them a home to ensure that they would be kept together forever – and of course we said yes.

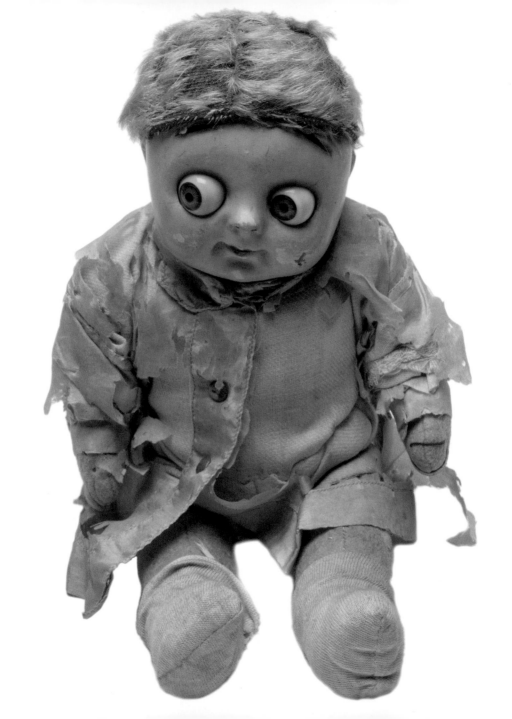

2

SEVENTEENTH- AND EIGHTEENTH-CENTURY DOLLS

Between 1600 and 1800 children played with a great variety of dolls of many different types, materials and levels of sophistication. The simple jointed wooden dolls that had existed since the Middle Ages began to be systematically exported from Germany in large numbers, as the woodcarvers of Thüringen, Berchtesgaden and Oberammergau sold their wares to travelling merchants, who bundled them in with collections of other goods and carried them far and wide. Craftsmen in the Netherlands made similar items. These were the commonest dolls of the period, and they were called by a number of different names: in England 'Dutch dolls' or 'Flanders babies', in colonial America 'peg dolls' or 'pennywoods'. Their hair and faces were painted onto the wood and they were often sold without any clothes, in the expectation that their new owner would sew them a dress out of scraps of spare material.

Cloth dolls were also popular, made from a stocking stuffed with sawdust or rags, with woollen hair sewn into the head. The eyes, nose and mouth were painted or inked onto the cloth, the limbs were added separately and then the doll was dressed in colourful patterned clothing.

By the eighteenth century, the wooden fashion dolls of earlier centuries were less common, but an interesting new variety appeared in England: the pedlar dolls. These represented London streetsellers, dressed in aprons, shawls and bonnets and holding trays or baskets containing a variety of miniature goods. Perhaps not so very different from the Irish flower-seller dolls that Tommy and Freda Noyek were selling in 1950!

London streetsellers, dressed in aprons, shawls and bonnets and holding trays or baskets containing a variety of miniature goods.

More elaborate versions of the simple wooden doll appeared as the eighteenth century progressed. Some dollmakers introduced movable arms by placing a small shaft inside the doll's shoulder and attaching the arms to this, allowing them to be lifted or rotated. Sometimes the wooden limbs were replaced by arms and legs made of kid leather, and the round staring eyes were softened by painted eyelashes and eyebrows. Occasionally the dolls had glass eyes, although nobody has been able to establish exactly when the first fixed glass eyes were used. Dolls' costumes also became increasingly magnificent, in imitation of the ornate hooped dresses worn by the little girls who owned them.

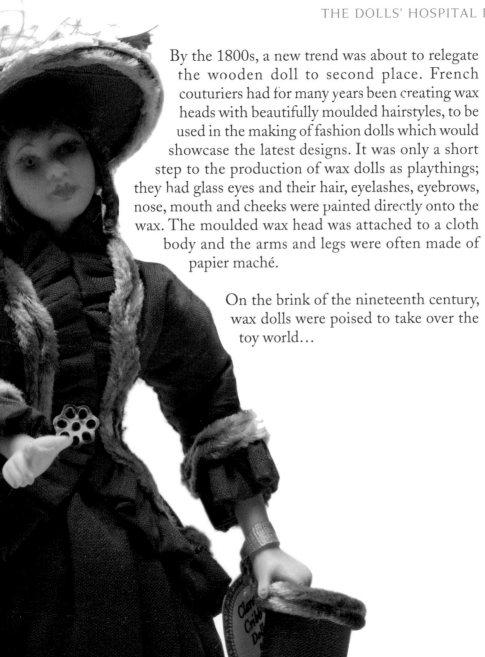

By the 1800s, a new trend was about to relegate the wooden doll to second place. French couturiers had for many years been creating wax heads with beautifully moulded hairstyles, to be used in the making of fashion dolls which would showcase the latest designs. It was only a short step to the production of wax dolls as playthings; they had glass eyes and their hair, eyelashes, eyebrows, nose, mouth and cheeks were painted directly onto the wax. The moulded wax head was attached to a cloth body and the arms and legs were often made of papier maché.

On the brink of the nineteenth century, wax dolls were poised to take over the toy world…

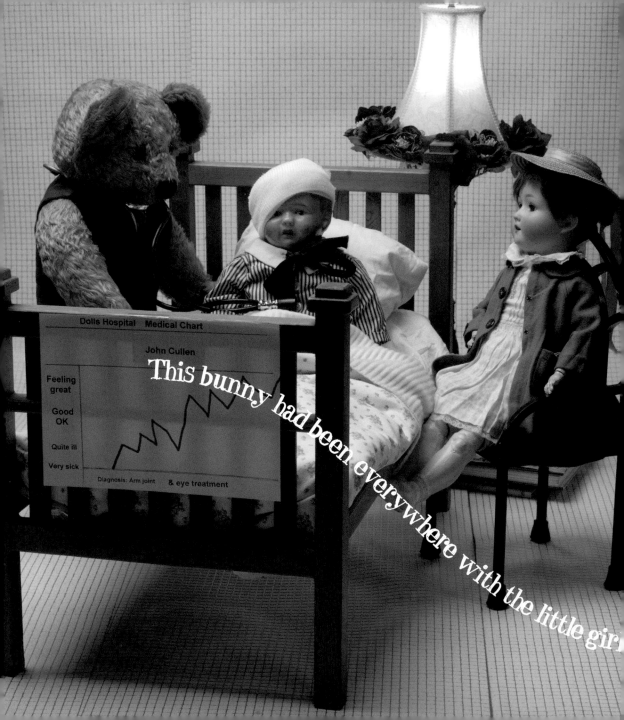

This bunny had been everywhere with the little girl

A Hospital Story

"We're often asked to repair dolls and teddy bears for sick children, who need their favourite toy to help them through the experience of going to hospital. On one occasion, we were contacted by a man in the Channel Islands, who told us that his young daughter had a serious heart condition and had undergone several operations. She was about to have another major operation, but there was a problem... her toy bunny rabbit, who always went to hospital with her, was very much the worse for wear. This bunny had been everywhere with the little girl over the years, not to mention going through the washing machine many times. Her father asked us if we could help.

The time came for the little girl to go into hospital, and her father explained to her that while she was having her operation, her bunny would also be getting some medical treatment. As she went to the hospital, her father went to the airport. He flew over to Dublin with the bunny and we went into emergency mode. Twenty-four hours later, the bunny was on the plane back to the Channel Islands,

not to mention going through the washing machine many times

looking as good as new, and we had also made him two pairs of new pyjamas. Every time the little girl went into hospital she got a new pair of pyjamas, so of course it was important for the bunny to have them too!

When she woke up in intensive care after the operation, the bunny was there beside her, restored to full health and looking very pleased with himself in his smart pyjamas.

We always leave spaces in our schedule for emergency cases like this one, because we know that the comfort of a much-loved toy can make all the difference to a child in hospital.

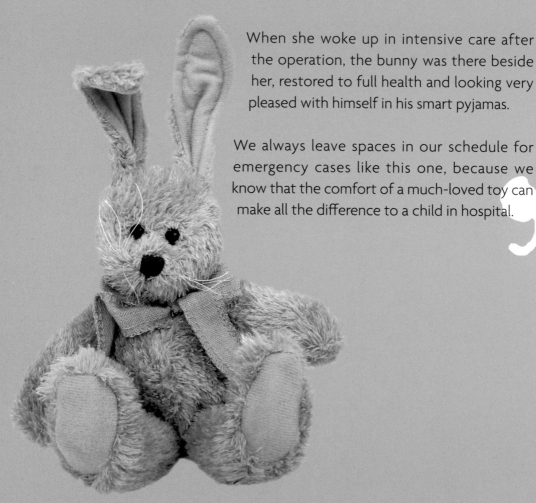

SECRET AGENTS

Some dolls have led more exciting lives than others. American dolls Lucy Ann and Nina are 150 years old and they are currently enjoying a peaceful retirement in the Museum of the Confederacy in Richmond, Virginia. But in their youth, they were secret agents!

During the American Civil War, Union forces in the north made it illegal to provide medical supplies to Confederate soldiers fighting in the south. Lucy Ann and Nina undertook a highly dangerous mission – they smuggled vital supplies such as morphine and quinine past the Union blockades in their hollowed-out papier maché heads.

Of course, the most enigmatic spies are always European, and Lucy Ann and Nina are no exception. It is thought that they were made and purchased in Europe, where their heads were packed with the precious cargo, before they embarked on their long voyage across the Atlantic Ocean, never to return. Lucy Ann has a gash on the back of her head, probably made in order to remove the medicines. Nina is in better shape and museum officials think she was probably taken apart and stitched back together again.

It is this willingness to be disembowelled in the service of your country that has traditionally made the world of espionage so glamorous…

finally, all those years later

A Horror Story

Some years ago, Melissa from the Dolls' Hospital took part in the Gerry Ryan radio show on RTE 2fm, asking listeners to phone in with their doll and teddy bear stories to compete for a prize. The story that won was a very disturbing tale...

A young girl in Dublin had a teddy bear that she absolutely loved, even though it was getting old and was a little bit ragged and dirty. She was given a new bear, but she didn't take to it – she always liked the old one best. One day her parents sat her down on the sofa, took the old bear apart limb by limb and burned it on the fire. 'There', they said, 'it's gone – and this is your new bear.'

When the girl, now an adult, phoned in to the radio show to tell her story, there was a huge public reaction — people were horrified! This all took place back in the 1980s, at the time when *Brideshead Revisited* was being screened on television, so as her prize we gave the girl an Aloysius bear. She later told us that Aloysius had broken the spell for her...

she had a teddy bear that she was able to love again

THE DOLLS' TEA PARTY

The dolls' tea party was a Victorian invention which arose from innovations in the manufacture of dolls' houses and their accessories. In the mid-nineteenth century there was a craze for tiny dolls' tea-sets and dinner services made of real china. Little girls were encouraged to seat their dolls around the table and serve tea to them – just as their mothers served tea to guests in the drawing-room. So the dolls' tea party wasn't just a game – it was a way of instructing children in the habits and manners of polite society.

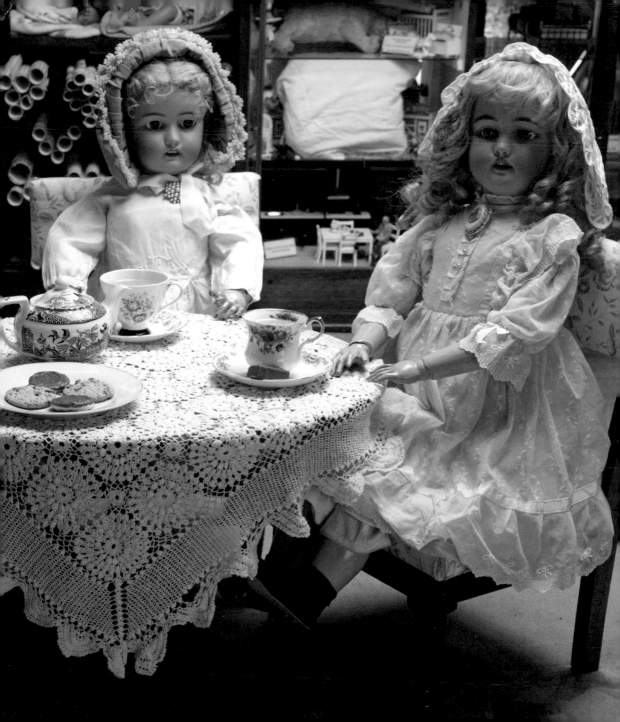

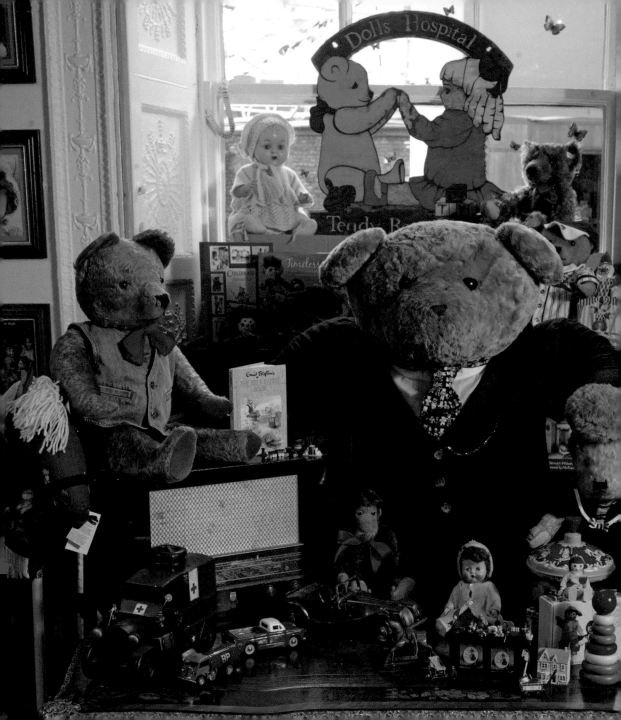

The Teddy Bears' Picnic

The catchy tune of 'The Teddy Bears' Picnic' was written by an American composer called John Walter Bratton in 1907 and originally named 'The Teddy Bear Two-Step'. But the song only achieved its current popularity when the Irish lyricist Jimmy Kennedy added the words in the 1930s. Jimmy Kennedy was born and educated in County Tyrone and later attended Trinity College Dublin, before moving to London where he wrote his most famous lyrics. Teddy bears have been picnicking ever since!

An Unrequited Love Story

" More than once, we've seen *we managed to piece Cheeky Bear* a doll or a teddy bear end up in the firing line when a relationship breaks down – nothing surprises us anymore! We were contacted once by a girl in Wales who had recently split up with her boyfriend. In a fit of rage, he took a pair of scissors and cut up her teddy bear, known as Cheeky Bear for his big happy smile. We think he might have seen the bear as a rival for her affections...

Cheeky Bear was in bad shape, but she sent him along to the Dolls' Hospital anyway, just in case we could do something. It was a big job, but we're not easily daunted and (with the aid of a pair of checked pyjamas) we managed to piece Cheeky Bear back together again and restore his smile. We sent him back to Wales and some time later the delighted owner sent us a photograph of herself and Cheeky Bear and a note saying that the boyfriend was gone forever. So the relationship was never put back together but the bear, happily, was. **"**

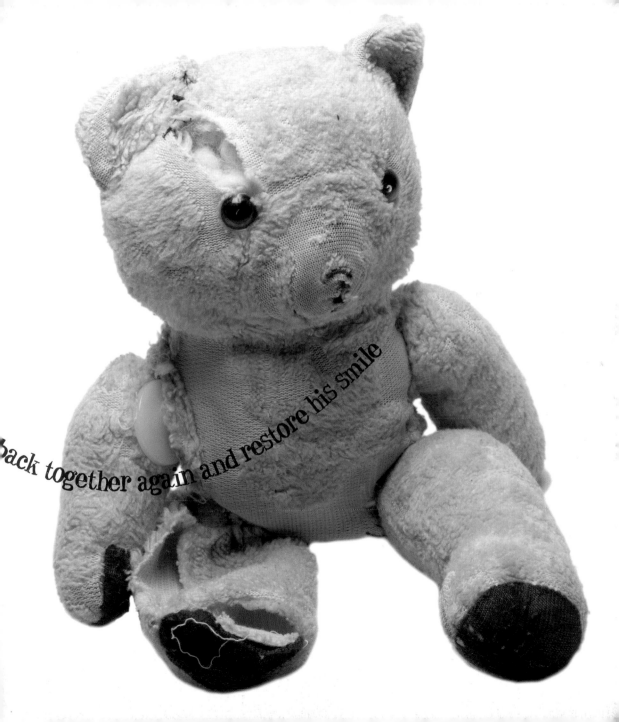

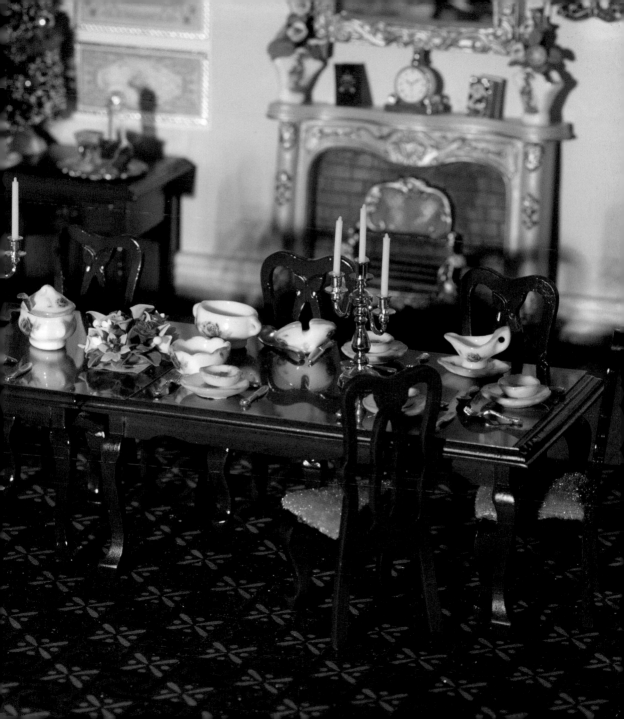

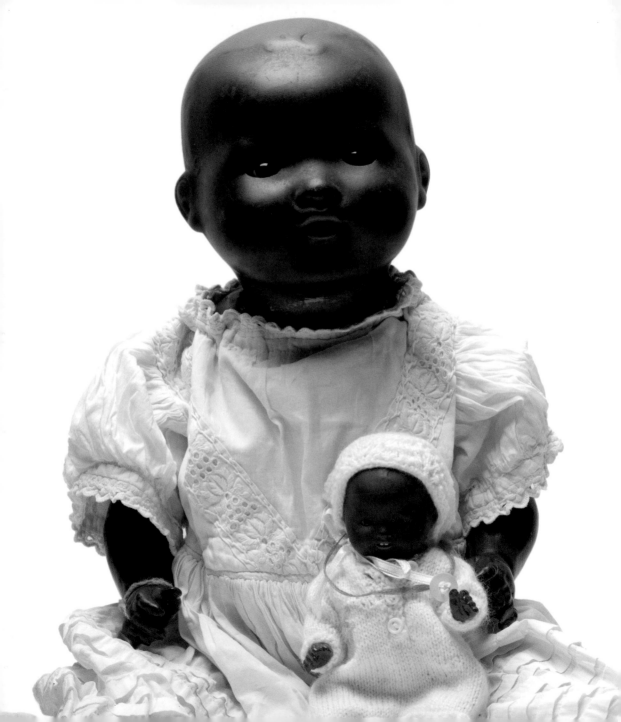

3

NINETEENTH-CENTURY DOLLS

Between 1800 and 1900, the doll's world expanded as never before. There were wax dolls, papier maché dolls, china dolls of all kinds, composition dolls, rubber dolls – and of course wooden dolls and rag dolls as well. Dollmaking became a fully fledged industry and the fashionable doll-about-town also had to be provided with clothes, a house, furniture, accessories and quite possibly a pram…

At the beginning of the century, demand for wax dolls was high and the family most closely associated with this type of manufacture were the Montanaris, whose dolls were wildly popular and a star attraction at the Great Exhibition held at Crystal Palace in 1851. Montanari dolls were far more lifelike than anything which had ever been seen before. Where older wax dolls had hair painted onto their heads, the Montanaris pioneered the technique of setting 'real' hair directly into the wax with a hot needle.

Another famous dollmaking family, the Pierottis, also specialised in poured-wax dolls which were prized for their delicately coloured complexions and realistic appearance.

The nineteenth century was characterised by innovations in doll manufacture. One of the new methods was to use papier maché and another was the use of composition (a mixture of materials such as sawdust, glue, resin, bran and plaster of Paris). The composition face would be painted in bright colours and then covered with a thin layer of wax.

There were also many variations of china and porcelain doll, including 'bisque', 'blonde bisque', 'stone bisque' and 'Parian'. These were all types of unglazed porcelain: 'bisque' dolls' heads were mixed with a large amount of colouring matter to make them pink in shade, 'blonde bisque' was less strongly coloured, 'stone bisque' was a coarse greyish-white and 'Parian' china was perfectly white, named after the Greek marble from the island of Paros. Usually it was just the head that was made of porcelain; the bodies might be made of cloth, leather, jointed wood, papier maché or composition.

Where older wax dolls had hair painted onto their heads, the Montanaris pioneered the technique of setting 'real' hair directly into the wax with a hot needle.

Both German and French factories made bisque dolls. The Germans produced them on a larger scale, but the French had the edge in terms of quality and desirability, particularly the dolls

produced by the famous Jumeau and Bru firms. These dolls were known for their big expressive eyes, their swivelling necks and their beautiful dresses, whereas the cheaper German dolls tended to be sold unclothed or wearing a simple chemise – in the expectation that the little girl who bought them could practise her sewing by making clothes for them.

Dolls' heads made from hard rubber were patented by the American inventor Charles Goodyear in 1851. They were displayed at the Great Exhibition the same year, and the *Illustrated London News* pointed out one very significant benefit of the new material: 'The heads of the dolls will bear any treatment. You may 'pitch into' them and knock them about any way and although they assume all sorts of odd appearances, they return with the greatest complacency to their former shape.'

the price of even quite sophisticated dolls was lowered and they became available to more than just a handful of very rich children.

Perhaps the single most important change that took place in the nineteenth century was the move to mass production of dolls in factories, with the result that the price of even quite sophisticated dolls was lowered and they became available to more than just a handful of very rich children. The classic Victorian doll in her lace-trimmed dress, with her blonde ringlets and her big blue eyes, was most at home in the middle-class nursery.

Of course this was still the exception rather than the rule – poorer children could never dream of possessing a toy like this. These children, who have now mostly faded from memory and from the records, nevertheless had their own treasured dolls. The Wenham Museum Doll Collection in Massachusetts contains a crude wooden doll known as 'Grandmother's Doll'. The face is painted straight on to the wood and the doll has taken a few knocks over the years (it could do with a visit to the Dolls' Hospital). This toy was brought to America from Ireland in the mid-nineteenth century, and undoubtedly the child emigrant who took it with her on the ship loved it as much as any wealthy little Victorian girl could have loved her much grander doll.

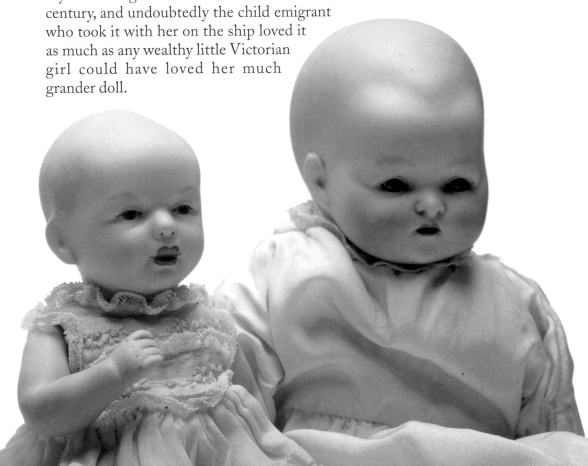

his bear would be safe with us and h

MADE IN IRELAND

A Grandmother's Story

"Often the dolls and bears that come into the Dolls' Hospital have a particular significance for their owner because they are associated with a family member. On one particular occasion, we were contacted by a grandmother in Limerick who had a special request to make. She explained that her young grandson had a bear which he treasured and kept with him at all times. It was the last gift the boy's father had given to him before his death. 'This bear is very much the worse for wear!' she told us, 'but I don't know how I can convince my grandson to be separated from it long enough for you to patch it up.' We told her to bring her grandson and his bear to Dublin so that they could see the Dolls' Hospital for themselves.

When they came in to visit us, the boy was clutching his bear tightly, and I think we were all worried that this wasn't going to work. But when we showed him round and he saw all the other toys, he was reassured that his bear would be safe with us and agreed to leave it in the Hospital for some medical treatment. Of course we put it on a 'fast track' and repaired it at top speed, so that the boy and the bear could be reunited again as soon as possible.

agreed to leave it in the Hospital for some medical treatment

BABY DOLLS

Until the nineteenth century, dolls were made to resemble miniature adults. Perhaps this should come as no surprise when we remember that children themselves were often dressed like tiny versions of their parents!

But by the mid-nineteenth century the baby doll was a fixture in any self-respecting nursery. The Montanari and Pierotti dollmaking families did most to popularise the trend with their wax baby dolls, often dressed in beautiful lace caps and robes.

In the early years of the twentieth century, new ideas about child development began to circulate, and it was felt that it would be healthier for children if baby dolls were made to look as lifelike as possible. In 1910 the German firm of Kammer & Reinhardt produced a realistically grumpy-looking baby doll with a bisque head and composition body, known ever since as the 'Kaiser Baby' due to rumours that it was based on the German Kaiser's infant son. In actual fact, the designer used his own six-week-old baby as a model. From this time on, many dollmakers would base their dolls on real children – for example, the American sculptor Grace Puttnam modelled her popular doll 'Bye-Lo Baby' on a three-day-old infant who she had seen in a local Salvation Army hospital.

This trend towards highly realistic baby dolls has never gone away. The Kaiser Baby and the Bye-Lo Baby are direct ancestors of the most recent phenomenon in the doll world – the incredibly lifelike 'reborn' baby doll.

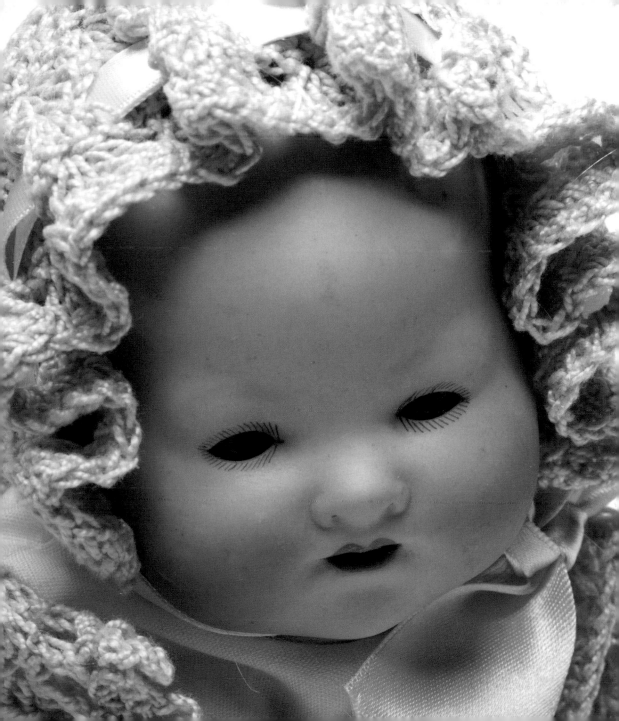

A War Story

An elderly lady contacted the Dolls' Hospital looking for somebody to take care of her doll. She was in a nursing home, and she worried that when she passed on her room would be cleared and the doll might be thrown away. When she told her story, we realised that we couldn't let that happen.

As a small child, she had been imprisoned in the Auschwitz concentration camp. After Auschwitz was liberated by the Allies in 1945, she came to England along with a number of other children who had somehow survived the camps. They were brought to London, where on their arrival each child was presented with a doll. It was supposed to be a kindly, welcoming gesture towards a group of small children who had witnessed unimaginable horrors, but when they handed her the doll, she immediately dropped it on the ground. She thought it was a dead baby.

it was a ghostly white and, with its staring eyes,

Once she understood what it really was, and that it had been presented to her as a gift, she picked the doll up and treasured it for the rest of her life. She always

kept it in wonderful condition and dressed it with great care. But the doll, which was made of plastic, had suffered an injury when she dropped it – its head had cracked and its eyes had become stuck in a kind of staring expression. As the years went by, the doll's face gradually became paler and paler through exposure to the light, while the rest of its body, which was covered by three layers of clothing, retained its original shade of pink. By the time she brought the doll in to us it was a ghostly white and, with its staring eyes, it looked as though it had seen something unspeakable – just like that little girl so many years before.

Of course we took the doll and gave it a good home. And one day, a regular customer of ours – a member of the RTE concert orchestra – came in to buy some miniature musical instruments, and in the course of conversation revealed that his wife had been imprisoned in Auschwitz during the war. We showed him the doll and told him the story, and he was very moved. The next day he came back to us, explaining that when he told his wife she had said 'I need to have that doll'. We agreed – we thought she was the right person to take it. They promised that when the time came, they would send the doll to the Jewish Museum in Portobello, and that's where it would end its days.

it looked as though it had seen something unspeakable

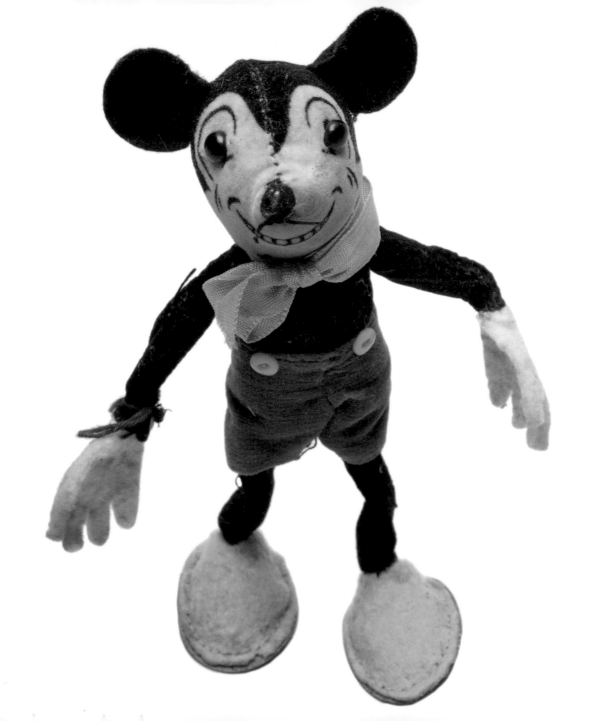

4

THE TWENTIETH CENTURY AND BEYOND

The end of the nineteenth century was a difficult time for the famous French dollmakers. By the late 1890s, the beautiful 'bébés' made by firms such as Jumeau and Bru were already of more variable quality than in previous years as the firms started to suffer financial difficulties, and in 1899 several well-known French toy companies were forced to join together for survival. The resulting consortium, the SFBJ, survived until the 1950s, but they faced incredibly tough competition from German firms such as Simon & Halbig and Armand Marseille.

Simon & Halbig made bisque dolls and also sold bisque heads, arms and legs to other doll manufacturers. But Armand Marseille was the best-known maker of bisque dolls, some with leather bodies, some with composition bodies, and some with pink canvas bodies attached to bisque arms. Their baby dolls were wildly popular – particularly a line called 'My Dream Baby' – and between 1900 and 1930 their factory allegedly produced 1,000 dolls' heads per day.

Throughout the twentieth century and up to the present day, dolls have been made from a wide variety of different materials in the wake of changing fashions and technical advances. In the years before the First World War, some children were still playing with wax dolls, but most dolls had bisque heads and their bodies were made either from composition or from leather or cloth stuffed with wood shavings or kapok. In the 1905 children's book *A Little Princess*, the seven-year-old heroine Sara Crewe receives a wonderful doll called Emily as a present from her father:

'She was a large doll, but not too large to carry about easily; she had naturally curling golden-brown hair, which hung like a mantle about her, and her eyes were a deep, clear, gray-blue, with soft, thick eyelashes which were real eyelashes and not mere painted lines [...] She had lace frocks, too, and velvet and muslin ones, and hats and coats and beautiful lace-trimmed underclothes, and gloves and handkerchiefs and furs.'

Much later in the book, Sara's fortunes take a turn for the worse and she is abandoned and left to fend for herself. In a memorable scene, she realises that her beloved Emily is no substitute for a human companion after all:

'You are nothing but a DOLL!' she cried. 'Nothing but a doll—doll—doll! You care for nothing. You are stuffed with sawdust. You never had a heart."

A few minutes later, though, she thinks better of it.

'You can't help being a doll,' she said with a resigned sigh [...].
'Perhaps you do your sawdust best.'

Later in the century, new materials such as soft rubber and celluloid
came into use. The famous Kewpie dolls were made first out of
bisque and later out of celluloid; they were mascot dolls with a
happy smile, a mischievous expression and a curl of hair running
down the middle of the
head. The first Kewpie
doll was produced in
1912, and they were
based on illustrations
by Rose O'Neill which
appeared in the *Ladies
Home Journal*. But celluloid dolls were flammable, which obviously
posed a danger to their owners, so they never really caught on.

> Kewpie dolls were made first out of bisque
> and later out of celluloid; they were mascot
> dolls with a happy smile, a mischievous
> expression

The historian Antonia Fraser points out that the 1930s Great
Depression had an unexpectedly positive effect on the toymaking
industry. Previously, toymakers had usually been forced to use scrap
materials, but the Depression changed all that. In the words of an
American manufacturer at the time: 'Auto scrap had been our raw
material for steel toys; dolls' dresses were made from the cutaway
of the ladies garment manufacturer; wooden toys from the off-fall
of the lumber mill. For the first time we were able to buy prime

material of high quality. Lumber mills, steel mills, textile mills were desperately looking for business during those Depression years and they were happy to find new customers in the growing toy manufacture'.

Rubber, plastic and later vinyl were the twentieth century's big success stories where dollmaking materials were concerned, and the number and variety of dolls on offer to children as the century progressed became ever greater. A quick look today at the website for Hamleys toyshop in London gives an idea of the range available: among many others, you can buy a 'Baby Annabell Time to Sleep Doll', a 'Shoe Obsession Barbie Doll', a 'Teeny Tiny Tears Doll' (these have been around since 1965), a 'Disney Princess Rapunzel' or a 'Royal Wedding Doll Set'!

*

One of the most striking elements of doll history in the twentieth century is that almost every decade has brought some sort of worry about the effect dolls are having on the moral, physical or psychological wellbeing of the child playing with them. As early as the 1900s, there was a movement for 'doll reform' in Germany, aimed mostly at the luxuriously dressed French dolls that had been popular for so long. Critics described them as soulless and frivolous and argued that they were encouraging little girls to become obsessed with outward appearances. In Munich in 1908, the German artist Marion Kaulitz exhibited some dolls modelled on the likenesses of real children. She had designed them herself and dressed them in local Bavarian costume and a sculptor, Paul Vogelsanger, moulded the dolls' heads. These dolls, known as the Munich Art Dolls, were noticed immediately by the toy industry, and the firm of Kammer & Reinhardt started to produce popular dolls based on real children. It was thought these dolls were healthier and more natural and even that they would train little girls for future motherhood.

After the First World War and throughout the 1920s and '30s this focus on 'good' and 'healthy' toys continued. The fabric dolls made by Käthe Kruse in Germany and by the Lenci Doll Company in Italy were prized for their craftsmanship and beauty, but also because they were soft and washable and so it was much easier for a child to 'mother' them. Writers, teachers and no doubt parents worried about how to choose the right toy for a child at a particular age – often changing their minds along with changing theories of child psychology.

This kind of worry leads on directly to the major doll controversy of the second half of the twentieth century: the Barbie wars. The American firm Mattel produced the first Barbie doll in 1959 (she was named after the designer's daughter Barbara). Barbie dolls have been enormously successful but have attracted endless criticism. Do they present an unrealistic role model for children? Do they create anxiety about body image as young girls strive to conform to an impossible beauty standard? There are plenty of supporters of Barbie as well as plenty of opponents, and the debate rages on. The Bratz dolls, created by MAG Entertainment and first released in 2001, have generated exactly the same criticisms. Perhaps it helps to put the whole thing in context if we remember that similar arguments seem to have been taking place for at least the last hundred years!

Writers, teachers and no doubt parents worried about how to choose the right toy for a child at a particular age

A Biker Story

It isn't just children who hate to be parted from their dolls and bears. Two of the Dolls' Hospital's regular customers are a biker couple who come in whenever they're about to go on their holidays and bring their teddy bears, because they don't like to leave them at home on their own. The bears' holiday is staying with us at the Dolls' Hospital – and they get spruced up and cleaned up while they're here!

The bears' holiday is staying with us at the

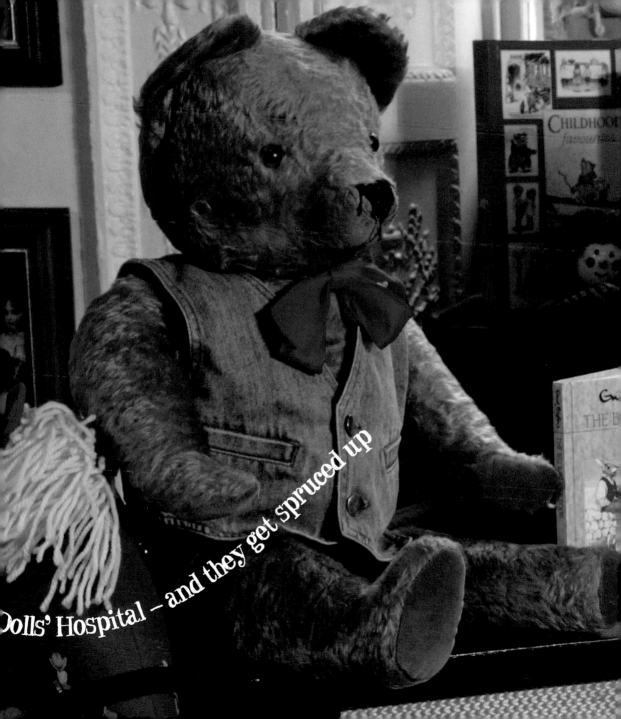

Dolls' Hospital – and they get spruced up

CROLLY DOLLS

The Crolly Doll is Ireland's best-loved doll and they have paid many a visit to the Dolls' Hospital over the years. In fact, the oldest Crolly Dolls are almost exactly the same age as the Hospital itself, since the Crolly Factory in Annagry, County Donegal, first started producing the toys in the late 1930s. The factory provided much-needed employment at a time when many people were being forced to leave Donegal and emigrate from Ireland, and the business became a byword for toymaking excellence.

The earliest dolls were handmade, with soft bodies and plaster heads, but from the 1950s onwards most Crolly Dolls were made from vinyl or plastic. They were beautifully dressed in Donegal tweeds and linens and hand-knitted woollen garments. Their popularity was astounding, and many Irish people still remember that their first doll was a Crolly Doll. At Christmas time, customers would queue outside shops for hours just to get hold of a Crolly Doll for their child; on more than one occasion a form of rationing had to be introduced, with buyers restricted to just one doll each!

Sadly, the Crolly Factory had no choice but to close in the 1970s, unable to face down competition from cheaper dolls manufactured in East Asia. Crolly Dolls are increasingly hard to find today and remain much treasured by those lucky enough to own one.

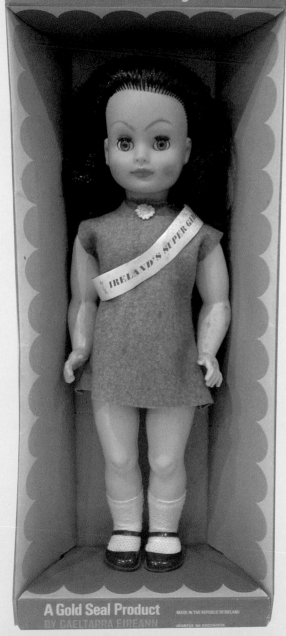

A Detective Story

There's no denying that even in this day and age, it's harder for a boy than a girl to admit they have a treasured childhood toy — even though at the Dolls' Hospital we know for a fact that boys (and grown men) love their bears as much as girls do.

One boy in particular had a shocking story to tell. He was very much attached to a *there was no way he was going* teddy bear which he had owned all his life, and as he got older his friends started to tease him about it. He would always laugh it off — there was no way he was going to abandon his bear just because of a few silly comments. Until one day the bear mysteriously disappeared.

It turned out that his friends had kidnapped it and were holding it hostage in an unknown location. As the days went by, the boy started to receive messages with photographs of his bear which grew gradually more and more sinister as the bear's kidnappers removed first one ear, then the other, and threatened that worse was to come.

A rescue operation was mounted and the bear was recovered and rushed into the Dolls' Hospital for emergency treatment. Luckily, as the boy understood, bears' ears can grow back very quickly sometimes. As for the culprits, they were never heard from again...

abandon his bear just because of a few silly comments

5

TEDDY BEARS

The teddy bear has to be, by some distance, the most famous, most influential and best-loved toy of the twentieth century – a true phenomenon in the toy world. But the question of the teddy bear's origins has been a subject of considerable debate, with both the USA and Germany staking a claim.

The American story goes like this. In the final months of 1902, a New York shopkeeper called Morris Michtom, whose business dealt in sweets and novelty items, displayed in his window a stuffed toy bear cub made by his wife Rose.

A report about the US president, Theodore Roosevelt, had recently been in the newspaper, describing one of Roosevelt's hunting expeditions down in Mississippi. Roosevelt had been hunting all day but with no success; he hadn't killed a single bear. Eventually, his worried companions chased down a black bear, tied it to a tree and called the President, inviting him to take a shot. Roosevelt firmly refused to shoot the animal in such unsportsmanlike circumstances, and the story of his gallantry was widely reported (although the details have been disputed since). The cartoonist

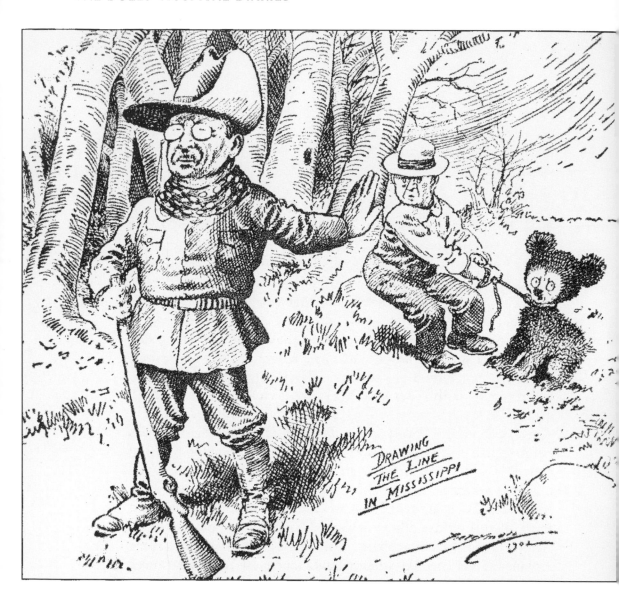

Cliff Berryman produced a popular cartoon illustrating the event and featuring a cuddly bear cub.

In a truly inspired marketing ploy, the Michtoms displayed their stuffed bear under the name 'Teddy's Bear' – Teddy being a common diminutive of the name Theodore. The bear was bought immediately and the craze started from there. By the end of 1903 the Michtoms had been able to set up their own firm, the Ideal Toy and Novelty Company, which prospered until the 1980s. 'Teddy's Bear' became the 'Teddy Bear' and dozens of American companies started to produce versions of the toy. They were so popular that some commentators even worried about the effect on the American birth rate if women started to prefer teddy bears to babies!

So there is no doubt of the American origins of the teddy bear's name, but were the Michtoms really the first creators of the toy bear? The German toy company Steiff have a strong case against their transatlantic cousins.

Steiff was a family company, originally founded by a dressmaker named Margarete Steiff. Margarete, who spent her life in a wheelchair after contracting polio as a child, started out as a seamstress but started to make stuffed toys in the 1880s. In the early years of the twentieth century, her son Richard Steiff designed a jointed toy bear made out of plush. This bear (codenamed 'Bear 55PB') might not have had much in common with what we would think of as a teddy today – it looked more like a real bear, with claws and a sharp nose – but it was a phenomenal hit at the Leipzig Toy Fair in March 1903, where a buyer for a New York department store placed a huge order for 3,000 bears.

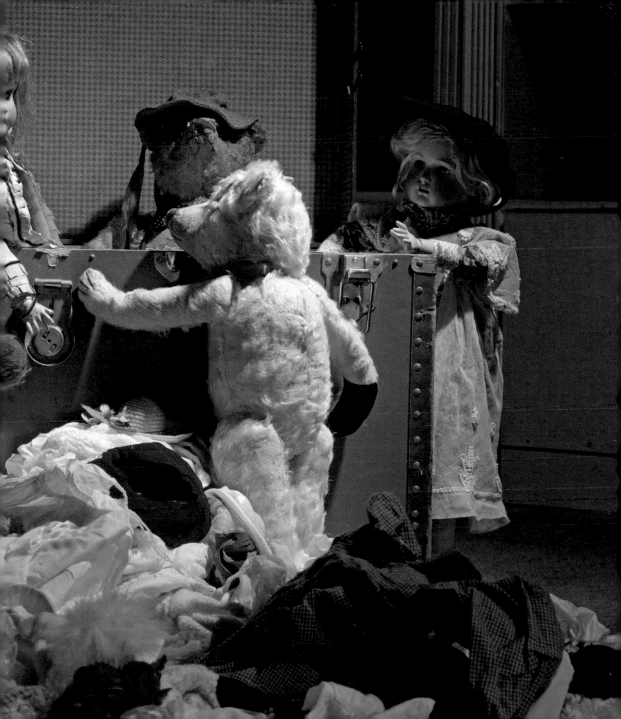

So it seems that the teddy bear was probably invented twice, on both sides of the Atlantic, at almost exactly the same time.

Over the next few years, the Steiff teddy bear's appearance changed. It became softer and more cuddly, with a broader face, boot-button eyes and a nose stitched from black thread. The period between 1903 and 1908 was known within the company as 'The Bear Years', as the success of the teddy exceeded their wildest expectations. Other companies jumped on the bandwagon, and Steiff began to distinguish their own bears from those of their competitors by inserting a small metal button into the left ear.

German companies dominated teddy bear manufacture in the first half of the twentieth century – not only Steiff, but also Hermann, Süssenguth, Bing and Schreyer & Company (Schuco). There were many variations and innovations: the 'growler', which worked by tilting the bear backwards; walking bears; somersaulting or 'tumbling' bears; bears with heads that move left and right or up and down (the 'Yes/No Bear'). Bears were covered in mohair plush, with the most popular shade being gold, and were stuffed with kapok or wood shavings.

> It became softer and more cuddly, with a broader face, boot-button eyes and a nose stitched from black thread

France, Austria, Holland and Britain also produced their own teddy bears and Britain has a special place in teddy bear history because of its association with famous bears such as Winnie the

Pooh and Paddington. Companies like Farnell, Dean's, Chad Valley, Pedigree Toys, Chiltern Toys and the Merrythought Company were the most famous British bear-making firms in the 1920s and '30s – a period which has been described as the 'Golden Age' of the teddy bear. We think of Winnie the Pooh exploring the Hundred-Acre Wood, Aloysius of *Brideshead Revisited* accompanying Sebastian Flyte on a drive through the countryside, Rupert the Bear in his bright yellow checked trousers and scarf, and of course the classic bear song 'The Teddy Bears' Picnic'.

Our love affair with the teddy bear looks set to continue. Michèle Brown, in her book *The Little History of the Teddy Bear*, puts her finger on the reason why: 'In the eyes of its owner, large or small, the teddy bear is dependable, trustworthy, loyal and in no way troublesome.' Teddy bears are our friends, the keepers of our secrets, companions in good times and comrades in bad times. At an auction held by Christie's of London in 2002, a century after the teddy bear's first appearance, a private collector paid over £4,000 for a little one-eyed bear called Edwin. Edwin belonged to Second-Lieutenant Percy Kynnersley-Baddeley, who took his bear to war with him in 1914. When Percy was killed two years later in the Battle of the Somme, Edwin was found tucked into the breast pocket of his uniform, his faithful companion until the very end.

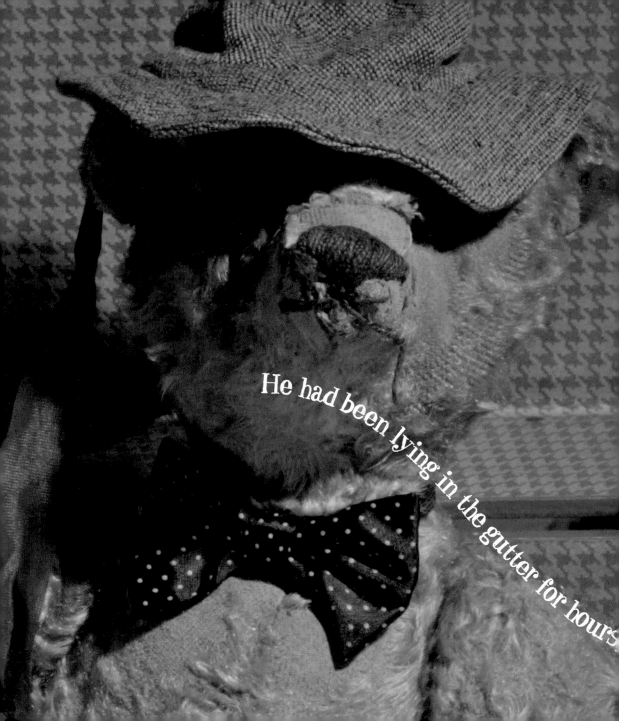

He had been lying in the gutter for hours

A Paddington Story

"It was a dark, stormy afternoon and the Dolls' Hospital was about to close for the night when the phone rang. The caller told us that he had just found a Paddington bear on the street out in Dun Laoghaire and the poor bear was in a terrible state. He had been lying in the gutter for hours, so he was filthy and soaking wet, and – even worse – at some point he had clearly been run over. The caller asked if anybody had been looking for the bear, but unfortunately nobody had. He asked if he could send him in to the Dolls' Hospital and we said of course, send him along... we'll see what we can do.

The next morning there was no sign of the bear, but at least the sun had come out. Before long, the phone rang again and this time it was a call from London. 'Is there any chance somebody might have handed in a Paddington bear? Our daughter lost her bear yesterday when we were on our way to the ferry to travel home. She's so upset, and I know it's a long shot but I thought I'd give it a try...'. 'Well,' we said, 'as it happens, we're expecting the arrival of a Paddington bear very shortly'.

So he was filthy and soaking wet

When the bedraggled bear arrived at the Dolls' Hospital, we had to carry out extensive repairs to restore him to his previous glossy condition. Then we sent him off to London by registered post (with a marmalade sandwich tucked under his hat in case of emergencies, obviously) to be reunited with his owner. What an adventure – and how nice to think that somebody really did bother to 'look after this bear'.

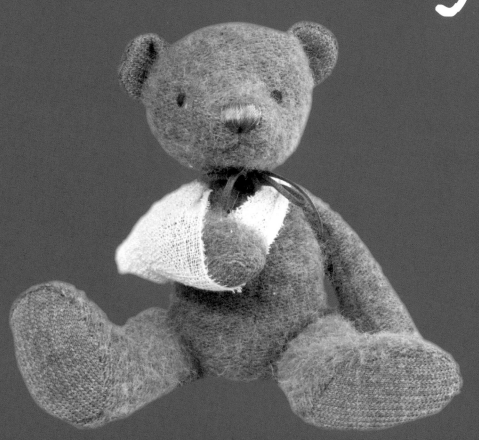

OUR FAVOURITE BEARS

Heffalumps, Honey and the House at Pooh Corner

Winnie the Pooh was the most famous creation of the author Alan Alexander Milne, who based the character on a teddy bear owned by his young son, Christopher Robin Milne. This bear was bought for Christopher Robin at Harrods of London in 1921, as a birthday present, and the first Winnie the Pooh stories were published in 1926. He was originally known as Edward Bear, but Christopher Robin changed his name after a visit to London Zoo where one of the star attractions was a Canadian brown bear cub called Winnie.

Generations of children have been enchanted by the stories of Winnie the Pooh and his friends: melancholy Eeyore, kindly Kanga and her son Roo, irrepressible Tigger and timid Piglet. The other animals were also based on Christopher Robin's toys, which are now on display in the New York Public Library, but not all of them have survived. The original Piglet reportedly had a rather bruising encounter with the family dog, and Roo was lost in an apple orchard near the Milnes' home in the 1930s.

You Pompous Old Bear

Aloysius is the teddy bear belonging to the whimsical Oxford undergraduate Lord Sebastian Flyte in Evelyn Waugh's classic novel *Brideshead Revisited*. He was based on the poet John Betjeman's teddy bear Archie, but was renamed in the book after St Aloysius, the patron saint of youth.

Aloysius accompanies Sebastian everywhere and, although frequently accused of being 'sulky', remains his faithful companion even after the carefree 1920s give way to the darker decades that follow.

In 1981, Granada Television broadcast a phenomenally successful adaptation of *Brideshead Revisited* starring Jeremy Irons and Anthony Andrews. Aloysius was played by Delicatessen, a very rare teddy bear made in 1907 by the Ideal Toy Company in America. The director of the television series, Derek Granger, described working with the bear as 'marvellous' and continued: 'He was never late on set, he never bumped into other actors and he was never drunk.'

From Darkest Peru
to 32 Windsor Gardens

Paddington Bear was based on a small teddy bear which the writer Michael Bond bought as a Christmas present for his wife in 1956. The first Paddington book, *A Bear Called Paddington*, was published two years later, and readers have been lapping up the adventures of the polite but accident-prone bear ever since.

Paddington's story begins when he travels to London from his home in Peru, with only his hat, his battered suitcase and a label round his neck reading 'Please look after this bear. Thank you.'

He is discovered on the platform at Paddington station by Mr and Mrs Brown, who decide to adopt him and – when he tells them his Peruvian name will be too difficult for people to understand – christen him Paddington after the place where he was found.

The little bear with a passion for marmalade became even more popular in the mid-1970s when he featured in an animated television series for the BBC. Each episode was only five minutes long but they had a very distinctive style, with a three-dimensional Paddington puppet filmed against a colourful two-dimensional background. And Paddington's appeal shows no sign of fading, with Warner Bros. set to release a new film about him in 2014.

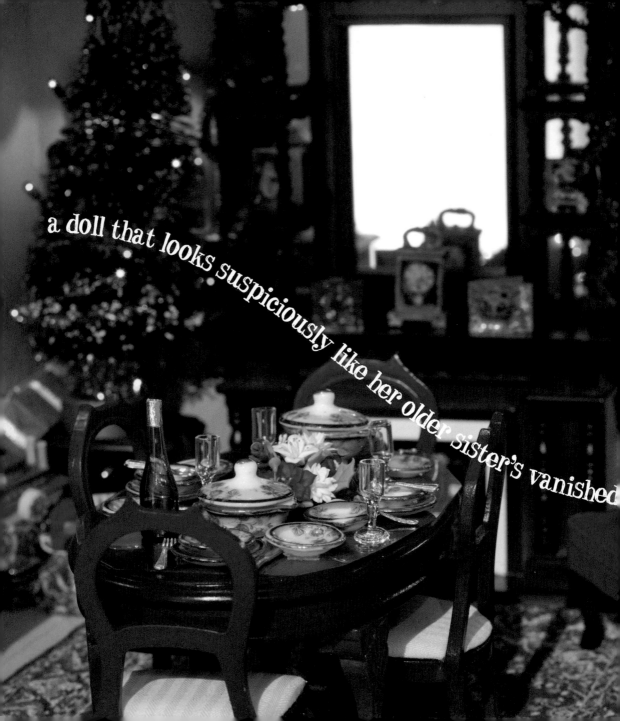

a doll that looks suspiciously like her older sister's vanished

A Christmas Story

Back in the old days, children didn't have as many toys as they do now. One story that we've heard time and time again is the tale of the much-loved doll who suddenly disappears in October. When Christmas day comes round, a younger child in the family finds in her stocking a doll that looks suspiciously like her older sister's vanished doll, just with a different outfit and a different hair colour! So the old Dolls' Hospital on Mary Street would have been particularly active in the makeover business during the run-up to Christmas...

doll, just with a different outfit and a different hair colour

One customer brought us a doll that had belonged most recently to her younger sister, but which she had reason to believe had once belonged to her. The doll had dark hair, and she asked us to change it back to its original blonde. 'I always knew!' she said. We made sure the doll was blonde again in time for Christmas.

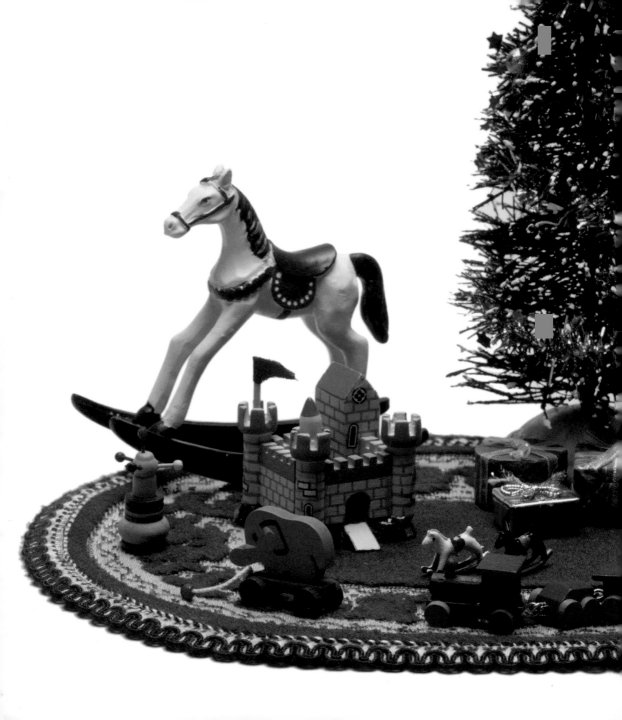

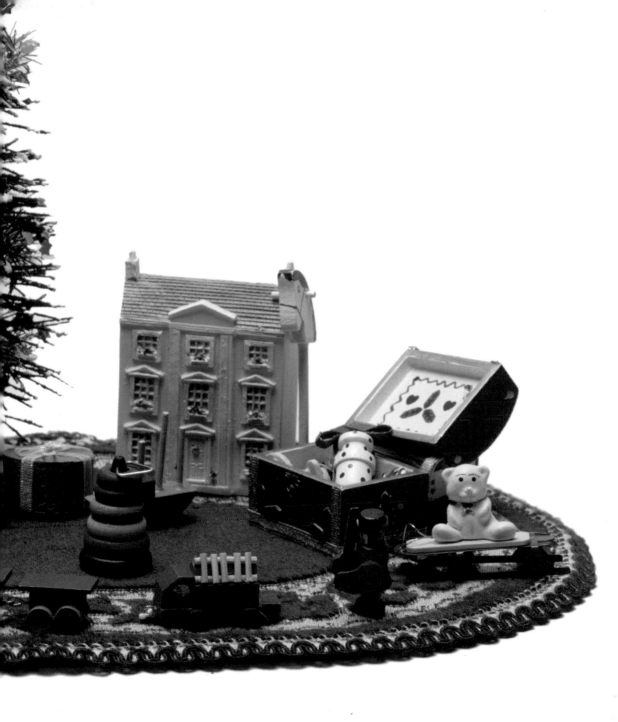

A Dolls' Hospital Bookshelf

Michèle Brown (2006), *The Little History of the Teddy Bear*, Stroud: The History Press Ltd

Leslie H. Daiken (1953), *Children's Toys Throughout the Ages*, London: Batsford

Antonia Fraser (1966), *A History of Toys*, London: Weidenfeld & Nicolson

Mary Hillier (1968), *Dolls and Doll-Makers*, London: Weidenfeld & Nicolson

Flora Gill Jacobs (1954), *A History of Dolls Houses: Four Centuries of the Domestic World in Miniature*, London: Cassell & Co.

Maribeth Keane and Jessica Lewis, 'An Interview on Antique Dolls with Museum Curator Noreen Marshall', *Collectors Weekly*, 10 June 2009